# BIOGRAPHIC
# MONET

# BIOGRAPHIC
# MONET

**RICHARD WILES**

AMMONITE
PRESS

First published 2016 by
Ammonite Press
an imprint of Guild of Master Craftsman Publications Ltd
Castle Place, 166 High Street, Lewes, East Sussex, BN7 1XU,
United Kingdom

Created for Ammonite Press by Biographic Books Ltd

ISBN 978 1 78145 289 9

Publisher: Jason Hook
Concept Design: Matt Carr
Design & Illustration: Matt Carr & Robin Shields
Editor: Jamie Pumfrey
Consultant Editor: Dr Diana Newall
Project Editor: Rob Yarham
Picture Research: Hedda Roennevig

Colour reproduction by GMC Reprographics
Printed and bound in Turkey

# CONTENTS

# ICONOGRAPHIC

WHEN WE CAN RECOGNIZE AN ARTIST BY
A SET OF ICONS, WE CAN ALSO RECOGNIZE
HOW COMPLETELY THAT ARTIST AND
THEIR WORK HAVE ENTERED OUR CULTURE
AND OUR CONSCIOUSNESS.

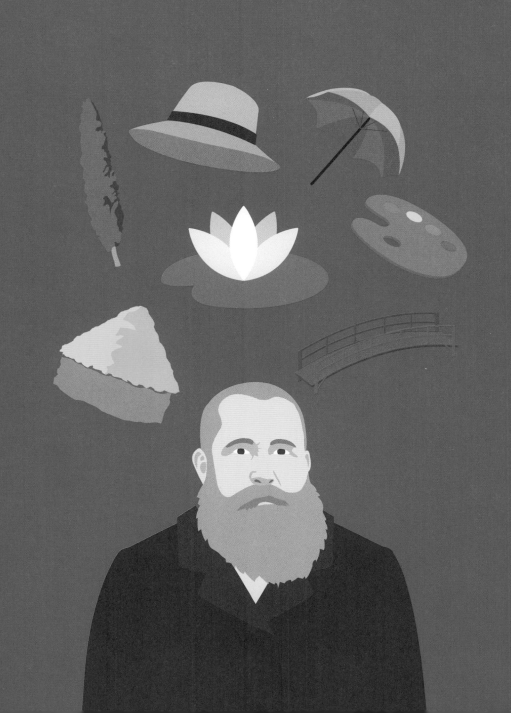

# INTRODUCTION

Avuncular, immaculately turned out in a white three-piece suit, with long white beard and sporting a Panama hat, a cigarette dangling from his lips, the elderly man stands before an easel, its canvas positioned to command a view of the glistening water lily pond and its backdrop of overhanging trees, shrubs and exotic plants. He daubs paint on the canvas, steals glimpses of the scene, reloads his brush from a large palette clamped to his left forearm, and continues with his work.

The rare, 1915 silent movie *Those of Our Land,* by young Russian-born, French actor Sacha Guitry, offers us this scene of Claude Monet, aged 74, in his twilight years. It is a charming glimpse into the world of one of the finest painters of the era. The scene had been enacted countless times since the artist moved to his home in Giverny, Upper Normandy in northern France, in 1883. By the time of his death in 1926, he had spent almost half his life in the property and the idyllic gardens he created.

Monet, despite a propensity for depression, and in later life suffering from poor eyesight, would appear to have been a happy, contented man, although he was driven by an insatiable urge to capture on canvas the ever-changing beauty of nature that surrounded him.

"I SAY THAT WHOEVER CLAIMS TO HAVE FINISHED A CANVAS IS TERRIBLY ARROGANT."

A family move from his place of birth, Paris, at the age of five, transplanted him to the beautiful Normandy coastline, where as a rebellious youth he would frequently play truant from school to gambol outdoors. He would come to spend much of his working life in the fresh air, after mentoring by local seascape artist Eugène Boudin, who, acknowledging Monet's latent talent, encouraged the boy to set aside his wryly observed charcoal caricatures and immerse himself instead in landscape painting *en plein air* – not in the studio, but in the open air.

Even formal art education in a respectable Paris studio could not confine the adventurous young man, who preferred the lure of open fields and riverbanks. Along with his newly made artist friends – who included Renoir, Sisley and Pissarro – he evolved a new style of painting that became known, originally with disparaging intent, as 'Impressionism'.

The depiction of the everyday life of ordinary people, and scenes of the changing environment, was a distinct break from the formal, structured paintings of historical events that predominated. The Impressionists' aim was to understand and document the effects of light on the local colour of objects, and how juxtaposed colours affected each other. They applied paint in rapid strokes of 'broken colour', mixing on the canvas rather than on the palette.

> "COLOURS PURSUE ME LIKE A CONSTANT WORRY. THEY EVEN WORRY ME IN MY SLEEP."

Monet's early years as a painter were fraught with financial hardship and rejection from the traditional salons of Paris that dictated the art world of the time. Unmarried, but with a young family to support, and alienated by his father (who disapproved of his choice of both partner and career), the penniless artist was obliged to rely upon the charity of his more affluent friends and associates.

With the eventual appreciation by the public of Impressionism as a fresh new genre of painting, alongside grudging acceptance from the staid art world,

came respectable sales of Monet's canvases and greater prosperity. He was able to put down roots in the village of Giverny – quite literally, since he embarked upon an ambitious landscaping project, cultivating and planting his land to create the famous pond filled with exotic water lilies.

These would become the focus of his paintings for the next 20 years, an astonishing production line of more than 200 canvases.

What set Monet apart from his contemporaries was his adoption of seriality: painting dozens of versions of the same view at different times of the day, and in different lighting and weather conditions, with obsessive verve. His water lily paintings, some of gigantic proportions, manage to capture the minutiae of detail with little more than a few deft brushstrokes that coalesce to form a rich, almost tangible impression of the scene before the viewer.

Even the failure of his eyesight did not deter him, and he forged on, creating paintings that, unintentionally, radically changed the nature of his canvases, which verged on the abstract. Although cataract operations and corrective glasses restored his vision and his former precision, paintings displayed a notable change that suggests he perceived colours differently.

"WHAT CAN BE SAID ABOUT A MAN WHO IS INTERESTED IN NOTHING BUT HIS PAINTING? IT'S A PITY IF A MAN CAN ONLY INTEREST HIMSELF IN ONE THING. BUT I CAN'T DO ANYTHING ELSE. I HAVE ONLY ONE INTEREST."

In 1918, the day after the Armistice at the end of the First World War was signed, Monet pledged to donate a series of paintings to the French nation as his 'monument to peace'. So commenced a mammoth undertaking that did not come to fruition in the artist's lifetime, but which now attracts visitors from around the globe to the Musée de l'Orangerie in Paris. Here, the enormous panels of *Water Lilies* are displayed in a fitting tribute to a world-changing artist.

# CLAUDE MONET

## 01
### LIFE

MONET

# "I DIDN'T BECOME AN IMPRESSIONIST. AS LONG AS I CAN REMEMBER I ALWAYS HAVE BEEN ONE."

—Claude Monet

# CLAUDE MONET

**was born on 14 November 1840 in Paris, France**

PARIS

Claude was born on the fifth floor of 45 Rue Laffitte, in the ninth arrondissement of Paris, France, the second son of second-generation Parisians, Claude-Adolphe Monet and Louise-Justine (née Aubrée).

On 20 November 1841, just after his first birthday, the artist was baptized Oscar-Claude in Notre-Dame-de-Lorette church. He was known by his parents and older brother, Léon, simply as Oscar.

Other famous Parisians include ▶
**Simone de Beauvoir, Édith Piaf** and **Maurice Chevalier** (right)

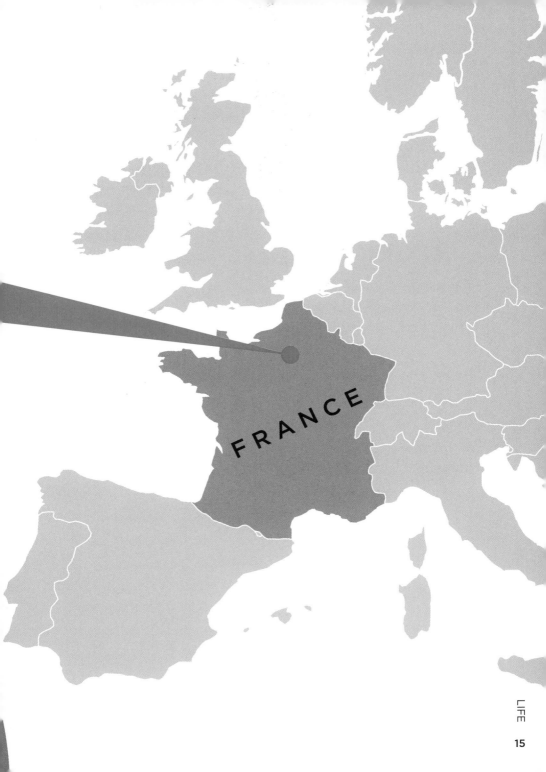

FRANCE

# On Monet's birthday...
# 14 NOVEMBER

**1524** Spanish conquistador, Francisco Pizarro, commences his first great expedition to conquer the Incan Empire, near Colombia, South America.

**1680** The Great Comet of 1680 (aka Kirch's Comet or Newton's Comet) is discovered by the German astronomer, Gottfried Kirch. It is the first comet to be discovered by telescope.

**1832** The first horse-drawn streetcar, with room for 30 people, goes into operation in New York City.

**1851** Herman Melville's novel *Moby-Dick* – the tale of Captain Ahab's quest for revenge on the white whale that destroyed his ship and severed his leg – is published in the USA by Harper and Brothers.

**1922** The British Broadcasting Corporation begins its radio service in the United Kingdom.

**1952** The *New Musical Express* publishes the first UK Singles Chart.

**1956** The USSR crushes the Hungarian uprising.

**1969** NASA launches Apollo 12, the second crewed mission to the surface of the Moon.

**2012** The game Candy Crush Saga is released as a mobile app for smartphones.

## 2 December USA

William Henry Harrison, a Whig candidate, becomes the ninth President of the United States. Aged 67, he dies from pneumonia 30 days after taking office.

The length of railroad track in the United States in the ten years since 1830 has increased from 100 miles (161 km) to 3,500 miles (5,633 km).

## 1 March FRANCE

Statesman and historian, Marie Joseph Louis Adolphe Thiers (1797–1877), a key figure in the 1830 July Revolution and the 1848 French Revolution, becomes the second elected President of France, and the first President of the French Third Republic.

# THE WORLD IN 1840

## 1 May BRITAIN

Great Britain issues the Penny Black, the world's first adhesive postage stamp.

## 12–23 June

The World Anti-Slavery Convention meets for the first time in Exeter Hall, London.

## 10 February

British Queen Victoria marries her cousin, Prince Albert of Saxe-Coburg and Gotha.

## 30 September

The frigate *Belle-Poule* docks at Cherbourg, bringing back the remains of Napoléon from Saint-Helena for burial in Les Invalides, Paris.

## 22 January NEW ZEALAND

Following an advance party the previous year, 150 British settlers, sailing on the *Aurora*, reach New Zealand and officially found Wellington. Four months later, New Zealand is declared a British colony.

# MONET TREE

Monet's father, Claude-Adolphe, was a Parisian grocer and his mother a singer. He had one older sibling, Léon Pascal. Monet married his model Camille Doncieux in 1870, three years after she had borne his first son, Jean. Camille died shortly after the birth of their second son, Michel. In an unconventional domestic arrangement, Monet's patron, art collector Ernest Hoschedé, moved his family into Monet's house after being declared bankrupt. On Camille's death, Hoschedé's wife Alice helped Monet to raise the boys alongside her own six children. After Ernest died in 1891, she married Monet the following year.

**1ST WIFE**

**Camille-Léonie Doncieux (1847–1879)**

**YOUNGEST SON**

**Michel Monet (1878–1966)**

**Jean Monet (1867–1914)**

**ELDEST SON**

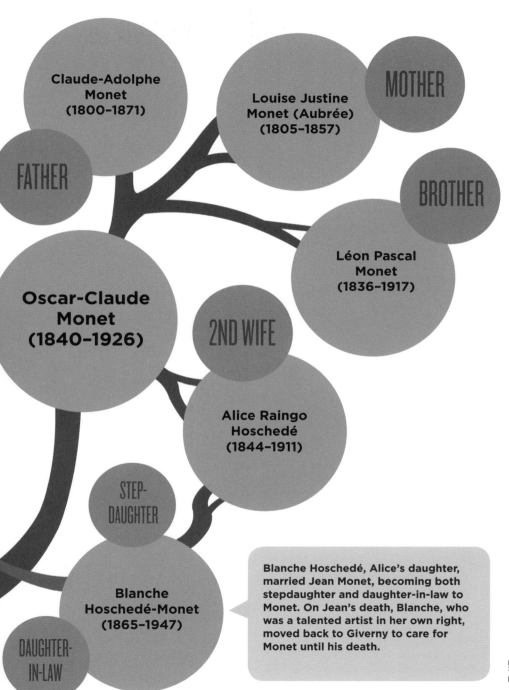

Claude-Adolphe Monet
(1800–1871)

Louise Justine Monet (Aubrée)
(1805–1857)

MOTHER

FATHER

BROTHER

Léon Pascal Monet
(1836–1917)

Oscar-Claude Monet
(1840–1926)

2ND WIFE

Alice Raingo Hoschedé
(1844–1911)

STEP-DAUGHTER

Blanche Hoschedé-Monet
(1865–1947)

DAUGHTER-IN-LAW

Blanche Hoschedé, Alice's daughter, married Jean Monet, becoming both stepdaughter and daughter-in-law to Monet. On Jean's death, Blanche, who was a talented artist in her own right, moved back to Giverny to care for Monet until his death.

# YOUNG
# MONET

"THIS CHILDHOOD OF MINE WAS ESSENTIALLY ONE OF FREEDOM. I WAS BORN UNDISCIPLINEABLE."

—Claude Monet,
*Le Temps* newspaper,
26 November 1900

LE HAVRE 195

## 1845

The Monet family moved to Le Havre, the Normandy coastal town, after Claude-Adolphe was offered a job in the grocery and ships' chandlery owned by Jacques Lecadre, the husband of Claude-Adolphe's half-sister, Marie-Jeanne. Monet's father wanted his youngest son to join the family business, but the boy longed to become an artist.

## 1851

On 1 April, 10-year-old Claude entered Le Havre Secondary School for the Arts and took his first drawing lessons from Jacques-François Ochard, a former student of the influential Neoclassicist painter, Jacques-Louis David.

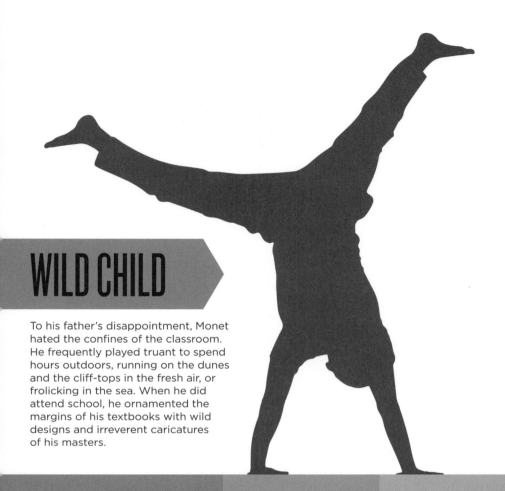

# WILD CHILD

To his father's disappointment, Monet hated the confines of the classroom. He frequently played truant to spend hours outdoors, running on the dunes and the cliff-tops in the fresh air, or frolicking in the sea. When he did attend school, he ornamented the margins of his textbooks with wild designs and irreverent caricatures of his masters.

## 1855

By the age of 15, Monet had become well known for his charcoal caricatures of the town's residents. The caricatures were displayed in the window of an art supply shop, and Monet would sell them for 10–20 francs: 'Depending on whether I liked the look of my clients or not'.

## 1857

Monet's mother, who supported his artistic enthusiasm, died on 28 January, when he was just 16 years old.

## 1858

After the death of Jacques Lecadre on 30 September, Monet left school and went to live with his wealthy, widowed and childless aunt, Marie-Jeanne.

# "ONE DAY BOUDIN SAID TO ME, 'LEARN TO DRAW WELL AND APPRECIATE THE SEA, THE LIGHT, THE BLUE SKY.' I TOOK HIS ADVICE."

**—Monet to critic and friend Gustave Geffroy on Boudin's influence, 1920**

On the Normandy beaches, around 1857, Monet met the local artist Eugène Boudin, one of the first French landscape painters to paint outdoors. Sixteen years Monet's senior, Boudin became the young artist's mentor, urging him to abandon his teenage caricatures and teaching him to use oil paints and the *en plein air* techniques for painting that would come to characterize Monet's work.

# THE ART STARTS

## 1859

Aged 19, Monet moves to Paris to pursue his art, enrolling as a student at the Académie Suisse. Meets artist Camille Pissarro.

## 1861

Serves in the military with the First Regiment of African Light Cavalry, stationed in Algiers, Algeria, on a seven-year commitment.

## 1862

On convalescent leave in Le Havre, after contracting typhoid, Monet is mentored by Dutch marine landscape painter Johan Barthold Jongkind.

## 1862

Returning to Paris, Monet is sent by Toulmouche to study under Swiss-born artist Charles Gleyre. He befriends fellow students Auguste Renoir, Alfred Sisley and Frédéric Bazille. Their experiments with the techniques of light *en plein air*, broken colour and rapid brushstrokes become the foundations of Impressionism.

## 1862

Aunt Marie-Jeanne Lecadre intervenes financially to get Monet discharged, so long as he agrees to the tutelage of artist Auguste Toulmouche, who had married one of his cousins.

## 1866

Monet's painting of his lover, Camille Doncieux, *The Woman in the Green Dress*, is selected by the Salon, the annual juried art exhibition.

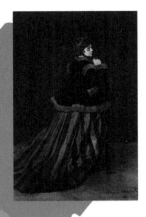

**ART**

**LIFE**

◀ *The Woman in the Green Dress*

▼ *Breakwater at Trouville, Low Tide*

## 1867

Monet and Camille's son, Jean, is born. Penniless, Monet leaves them in Paris to go and live with his aunt at Sainte-Adresse, in Normandy.

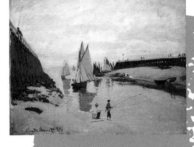

## 1870

Monet meets Paul Durand-Ruel, who has opened a gallery on Bond Street. Durand-Ruel exhibits Monet's *Breakwater at Trouville, Low Tide*.

## 1867

Achieving only occasional success, Monet relies on the goodwill of Bazille, who allows him to stay at his studio, along with Renoir.

## 1870

Monet and Camille marry on 28 June 1870. Aunt Marie-Jeanne dies and the Franco-Prussian War begins. Destitute, the family flee to London.

# MAKING AN IMPRESSION

To present their works outside the salons, Monet, Pissarro, Sisley and Renoir formed a society of independent artists – the Société Anonyme Coopérative d'Artistes Peintres, Sculpteurs, Graveurs. Their first exhibition was hosted at the photographic studio of Nadar – the pseudonym of Gaspard-Félix Tournachon, a photographer, caricaturist, journalist, novelist and balloonist – and would later be known as the 'Exhibition of the Impressionists'. On display was Monet's *Impression, Sunrise*, which prompted critic Louis Leroy to label the group 'Impressionists' in a satirical review published in the newspaper *Le Charivari*.

The Boulevard des Capucines, in the second and ninth Arrondissements, is one of four 'grands boulevards' in Paris, running east–west, including Boulevard de la Madeleine, Boulevard des Italiens and Boulevard Montmartre. The name refers to a convent of Capuchin nuns whose garden lay on its southern side prior to the French Revolution.

"IMPRESSION – I WAS CERTAIN OF IT. I WAS JUST TELLING MYSELF THAT, SINCE I WAS IMPRESSED, THERE HAD TO BE SOME IMPRESSION IN IT... AND WHAT FREEDOM, WHAT EASE OF WORKMANSHIP! A PRELIMINARY DRAWING FOR A WALLPAPER PATTERN IS MORE FINISHED THAN THIS SEASCAPE."

—Louis Leroy, *Le Charivari*, 25 April 1874

MONET

26

RUE DES CAUMARTIN

RUE SCRIBE

M
OPÉRA

BOULEVARD DES CAPUCINES

RUE CAMBON

RUE DES CAPUCINES

RUE DE LA PAIX

AVENUE DE L'OPÉRA

Nadar

# MONET
# THE MAN

## 1871
After his father dies, Monet leaves London to paint in Zaandam, Holland, later returning to Paris, where he rents a house in Argenteuil on the Seine.

## 1872
Durand-Ruel buys many of Monet's paintings and exhibits them in London. Monet uses his newfound prosperity to convert a boat into a floating studio.

## 1873
Monet, Pissarro, Sisley and Renoir form the Société Anonyme Coopérative d'Artistes Peintres, Sculpteurs, Graveurs. It goes bankrupt the following year.

## 1876
A second Impressionist exhibition, at Durand-Ruel's gallery, features 18 works by Monet, but the public response is hostile. Camille suffers tuberculosis.

## 1877
Gustave Caillebotte buys works by Monet and rents a studio for him near the Gare Saint-Lazare – subject of a dozen paintings in the third Impressionist exhibition.

## 1878
Monet's second son, Michel, is born. Monet rents a house in Vétheuil, on the Seine. After Hoschedé's bankruptcy, he, his wife Alice and their six children move in.

## 1879
Caillebotte finances the fourth exhibition of Impressionists, which includes 29 works by Monet. Camille Monet dies after a long illness.

## 1883

In May, Monet rents a house for his expanded family at Giverny, on the Seine, setting up his studio in a barn.

## 1891/92

Ernest Hoschedé dies, and Alice and Monet marry the following year.

## 1893

An increasingly wealthy Monet, who has purchased the Giverny house, land and water meadow, creates a series of lily ponds at the property.

## 1899

Monet begins to produce paintings of the ponds, their water lilies and the Japanese bridge – subjects that will dominate his work for 20 years.

## 1911

Alice dies. He begins to show signs of cataracts.

## 1914

Monet's eldest son, Jean, dies. Monet works on a series of mural-sized *Water Lily* canvases, and constructs a new studio to house them.

## 1920

Monet announces he will donate 12 *Water Lily* paintings to the State, which will be permanently displayed in the Orangerie des Tuileries, Paris.

## 1923/24

Monet undergoes two operations to remove cataracts. He obtains corrective glasses in an attempt to complete his *Water Lily* murals.

# FAILING VISION

Monet possessed an exquisite sensitivity to light, colour and detail, but in 1912 he was diagnosed with double cataracts, which cause the lens of the eye to become denser and yellowish over time.

Frustrated with his deteriorating vision, he had to memorize where he had placed colours on his palette and relied upon the labels of the tubes of paint when selecting them. In his paintings during this period, tones are muddied, and forms less distinct – notably *The Japanese Bridge* (1924), which has uncharacteristically large brush strokes and strong colouration. Glare prompted Monet to wear a broad-brimmed Panama hat and he retreated into his studio to work in the middle of the day.

Critics suggested that Monet's work was becoming more abstract, but this was probably unintentional compensation for his problem rather than a stylistic change. After cataract surgery in 1923, and wearing newly obtained glasses, he returned to his original painting style, having destroyed many paintings produced during the period when his vision was at its worst.

**As Monet developed cataracts, he saw colours differently – whites became yellows, greens became yellow-greens, reds became oranges, and blues and purples became reds and yellows. Shapes also blurred and Monet was unable to make out details.**

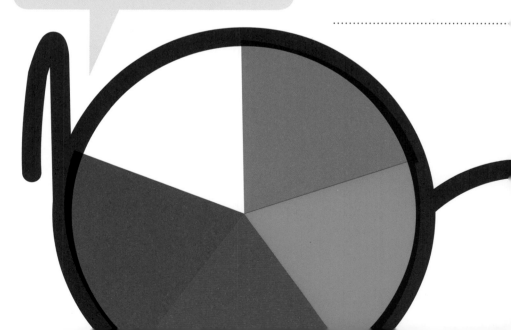

## COLOURS BEFORE CATARACTS

## COLOURS WITH CATARACTS

**Claude Monet, a heavy smoker for years, died of lung cancer, described by his doctor, Jean Rebière, as 'Damage and congestion at the base of the left lung'. His friend, the statesman Georges Clemenceau, was at his side.**

Monet was buried in the cemetery of the Eglise Sainte-Radegonde, Giverny, just 10 minutes from his house. The ceremony was simple, as the artist had wished, and attended by only around 50 people.

The family grave is planted with flowers, changed seasonally. Monet lies not only with his second wife Alice, his two sons Jean and Michel and their wives, but also Suzanne, a daughter of Alice and, somewhat unusually, Alice's first husband Ernest Hoschedé. Ernest had died first, and his children – who were raised by Monet – wished him to be nearby. When Suzanne died, it was natural that she should be buried with her father, and when Alice died she joined her daughter. Monet, who died next, was placed with his wife.

> HERE LIES
> OUR BELOVED
> ## CLAUDE MONET
> BORN NOVEMBER 14, 1840
> DIED DECEMBER 5, 1926
> MISSED BY ALL

> MONET IS BURIED NEXT TO:
> ALICE (second wife)
> JEAN (son) and his wife
> MICHEL (son) and his wife
> SUZANNE (Alice's daughter)
> ERNEST HOSCHEDÉ
> (Alice's first husband)

# CLAUDE MONET

# 02
## WORLD

# "ASIDE FROM PAINTING AND GARDENING...

# "...I'M GOOD FOR NOTHING."

—Claude Monet

# RIVER OF LIFE

For much of his long life, Monet gravitated to the winding banks of the River Seine. His artistic output was inspired by the river, the countryside that flanks it and the coastal reaches that extend beyond its mouth. It was the source of his finest paintings but also the symbol of his lowest ebb: in 1868, despairing at his financial difficulties, he attempted suicide by throwing himself into the river.

## 01 ARGENTEUIL
### 1871–1878

**Monet rented a house at Argenteuil, and converted a boat on the Seine into a floating studio.**

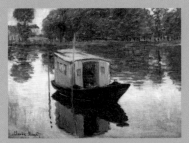

▲ *The Studio Boat*
Oil on canvas, 1874
19 x 25 inches (50 x 64 cm)

## 02 VÉTHEUIL
### 1878–1881

**A pretty, pink-painted house, with a lush garden running down to the river, featured in many of Monet's paintings.**

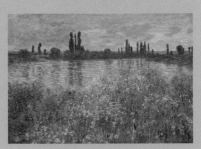

▲ *Banks of the Seine, Vétheuil*
Oil on canvas, 1880
29 x 40 inches (73 x 101 cm)

## 03 POISSY
### 1881–1883

**Living above his means, Monet rented Villa St Louis, a substantial mansion on the river. Troubled by his unconventional family arrangement and finances, he spent little time in 'this horrible Poissy'.**

## 04 VERNON
### 1883

It was while commuting on the train to his rented house in Vernon that Monet first glimpsed the village of Giverny, 2.5 miles (4 km) away.

## 05 GIVERNY
### 1883-1926

The 'House of the Cider-Press' became the home, studio, project and muse behind the outpouring of Monet's greatest works.

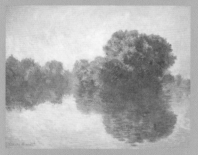

▲ *The Seine at Giverny*
Oil on canvas, 1897
32 x 40 inches (82 x 101 cm)

04 05 02

RIVER SEINE

← LENGTH →

# 483 MILES (777 KM)

01

03

**PARIS**

"I HAVE PAINTED THE SEINE THROUGHOUT MY LIFE, AT EVERY HOUR, AT EVERY SEASON. I HAVE NEVER TIRED OF IT: FOR ME THE SEINE IS ALWAYS NEW."

—Claude Monet, 1924

# PAINTER BY NUMBERS

## 1 ELDER BROTHER

Léon Monet (1836–1917) lived in Rouen, where he was a chemist.

## 2 WIVES

Camille Doncieux died in 1879, aged 32. They had been married for 9 years.

Alice Hoschedé died in 1911, aged 67. They had been married for 19 years.

## 2 CHILDREN

by Camille Doncieux.

# 6 STEP-CHILDREN

**Second wife Alice's children were brought up by Monet when their father died in 1891.**

# 5 HOMES

**Before moving to Giverny, Monet and his first wife Camille had lived in Le Havre, Paris, Étretat, Argenteuil and Vétheuil, moving around, often in the dead of night, to avoid angry landlords and creditors they could not afford to pay.**

# 43 YEARS IN GIVERNY

**By the time he died in 1926, 86-year-old Monet had spent almost half his life in his Giverny home.**

# MOVING MONET

Although Monet spent much of his life along the River Seine, he also ventured much further afield. His travels were reflected in his series works, whether it was the bridges of foggy London; the windmills of the Netherlands, where the authorities suspected him of revolutionary activities; the canals of Venice, or the mountains of Norway.

## LONDON

Monet took refuge in London at the outbreak in 1870 of the Franco-Prussian War. He studied the works of John Constable and JMW Turner, and returned to the city from 1899 to 1905. Entranced by the atmospheric fog, Monet painted Charing Cross Bridge, Waterloo Bridge and the Houses of Parliament, among his most enduring series works.

## ROUEN

During 1892 and 1893, Monet rented space across the street from Rouen's imposing cathedral and painted more than 30 canvases, which he reworked the following year in Giverny.

## CREUSE VALLEY

Monet captured the grandeur of the Creuse Valley when visiting Fresslines in the Massif Central region of France in 1889, and was inspired to begin his series paintings.

## ANTIBES

Like many painters, Monet was drawn to the light of the south of France. He painted about 40 canvases around the coastal resort of Antibes in four months in 1888, a precursor to his later series.

## NORWAY

Monet toured Norway in 1895 with his stepson, Jacques Hoschedé, who lived in Christiania (now Oslo). Captivated by the country, he was frustrated in efforts to find good motifs in the snowbound landscape by his inability to ski. He did, however, paint 29 scenes during his two-month stay.

## AMSTERDAM

In 1871, Monet spent six months in the Netherlands, in Zaandam and nearby Amsterdam. He painted 25 canvases of the windmills and canals, and returned there in 1874.

## VENICE

Travelling to Venice with Alice in 1908, Monet painted 37 canvases. He adored the city, but considered his work 'Only trials and beginnings.' He finished the paintings afterwards in the studio, two years later. His views are like tourists' postcards, depicting landmarks such as the Grand Canal and Doge's Palace.

## BORDIGHERA

Early in 1884, Monet travelled to Bordighera on the Italian Riviera, close to the border between France and Italy. Intending to stay just three weeks, he remained for three months.

## MONET'S HOMES

**Paris**
1840–1845

**Le Havre**
1845–1859

**Argenteuil**
1871–1878

**Vétheuil**
1878–1881

**Poissy**
1881–1883

**Vernon**
1883

**Giverny**
1883–1926

WORLD

41

# CLAUDE MONET
## 1840 – 1926

Claude Monet and Auguste Renoir were exact contemporaries, born just three months apart. The pair met and became close friends when studying in the art studio of Charles Gleyre, in Paris in 1862. Often painting the same subject side-by-side, *en plein air*, they shared stylistic techniques and their new approach to art in what became known as Impressionism. But how did their art diverge to take on their own unique characteristics?

## FAMILY

**Father: grocer**
**Mother: singer**
**Siblings: 1**

## PALETTE

**6 colours**

## ART EDUCATION

**Both studied under Charles Gleyre**

## MAIN MEDIUM

**Both painted with oil on canvas**

## EARLY STYLE

**Broken colour technique in depiction of light, water and reflections, with emphasis on the colour of shadows *en plein air***

## FAMILY

**Father: tailor**
**Mother: dressmaker**
**Siblings: 6**

## PALETTE

**6 colours**

## LATER STYLE

Looser brushwork, less concentration on form, verging into abstract, and latterly huge canvases

## SUBJECTS

Landscapes, seascapes in varying light and weather conditions, series work (e.g. *Haystacks*, *Water Lilies*)

## REPRESENTATION

**Paul Durand-Ruel**

# AUGUSTE RENOIR
## 1841 – 1919

## SUBJECTS

Landscapes, figurative work, domestic scenes, nudes and images of feminine sensuality

## LATER STYLE

Tight, classical manner with bold outlines, and black for contrast, with less focus on brushstrokes and more on form and contour

# CHARACTER STUDY

Headstrong, opinionated, stubborn, Monet was known to sulk when things did not go his way. He was also a man who guarded his privacy. Although dogged in his work ethic, he did not consider painting a job, but his life's work.

"WHETHER MY CATHEDRAL VIEWS, MY VIEWS OF LONDON AND OTHER CANVASES ARE PAINTED FROM LIFE OR NOT IS NOBODY'S BUSINESS AND OF NO IMPORTANCE WHATSOEVER."

—Claude Monet

## OBSTINATE

When he heard that the land on which the subject of his unfinished *Poplars* series was to be sold and the trees felled, Monet bought the land so that he could continue undisturbed.

**24**
**Poplars**

## TENACIOUS

Monet's series paintings reveal a tenacity that drove him to revisit the same subject matter scores of times, driven to record how the perception of light affected colour through the seasons, at various times of the day, and in different weather conditions.

**250**
**Water Lilies**

## OBSESSIVE

Although his original principle was to paint entirely *en plein air*, in later life Monet laboured over canvases in the studio, constantly refining and amending, working from memory or from sketches and photographs.

**25**
**Haystacks**

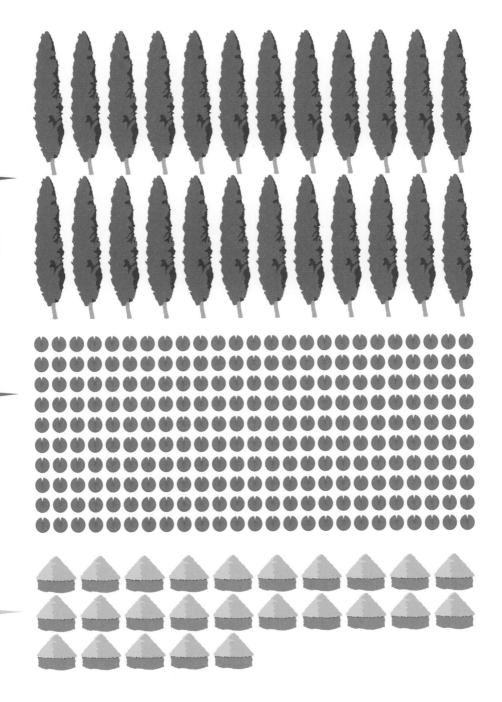

# CHAIN SMOKER

Monet reputedly chain-smoked cigarettes for much of his adult life – in a 1915 silent film a long sequence shows the artist at work in his garden painting water lilies, a cigarette dangling constantly from his lips. As he walks away in the final scene, he can be seen retrieving a pack from his jacket pocket and taking out another cigarette. Monet died of lung cancer.

# SOME OTHER BIG SMOKERS...

# CIGARETTES PER DAY

120 — JOHN WAYNE

80 — PABLO PICASSO

60 — FRANK SINATRA

60 — GEORGE HARRISON

WORLD

47

# MONET'S FLOATING WORLD

Claude Monet was a passionate collector of Japanese woodblock prints, after having first encountered them being used as wrapping paper in a spice shop in the Netherlands. Although he never travelled to Japan, he surrounded himself with examples of *Japonisme*. The style of gardens from 'the land of the rising sun', with the planting of exotic native Japanese species, were features integral to his own garden in Giverny. His paintings of the green humpbacked bridge spanning his water lily pond have distinct echoes of Hiroshige's *Inside Kameido Tenjin Shrine*, 1856.

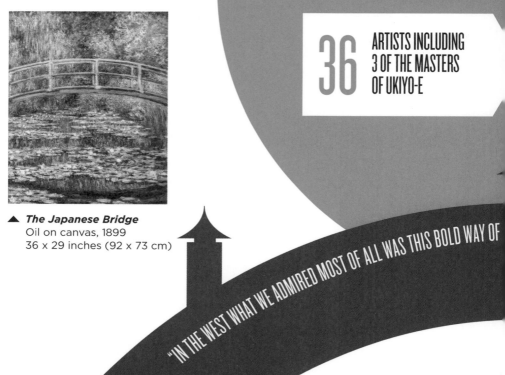

▲ *The Japanese Bridge*
Oil on canvas, 1899
36 x 29 inches (92 x 73 cm)

MONET'S PRINT
COLLECTION INCLUDED

# 231 PRINTS

## 36 ARTISTS INCLUDING 3 OF THE MASTERS OF UKIYO-E

"IN THE WEST WHAT WE ADMIRED MOST OF ALL WAS THIS BOLD WAY OF

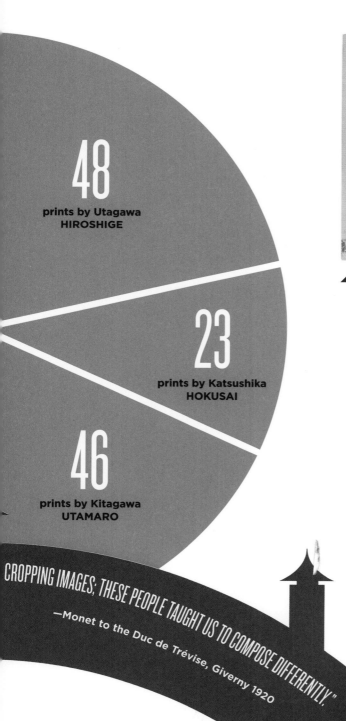

**48**

prints by Utagawa
**HIROSHIGE**

**23**

prints by Katsushika
**HOKUSAI**

**46**

prints by Kitagawa
**UTAMARO**

"CROPPING IMAGES; THESE PEOPLE TAUGHT US TO COMPOSE DIFFERENTLY."
—Monet to the Duc de Trévise, Giverny 1920

▲ **Inside Kameido Tenjin Shrine**
Woodblock print, 1856
13 x 9 inches (34 x 22 cm)

The exquisite, colourful woodblock prints that influenced Monet and many of his Impressionist colleagues were called 'Ukiyo-e', which translates as 'pictures in the floating world'. The prints, which were popular with the Western merchant class from the 17th through to the 19th centuries, depict hedonistic scenes from Japanese history, folk tales, landscapes and travel, flora and fauna, female beauties, kabuki actors, sumo wrestlers and erotica.

# 5 THINGS YOU DIDN'T KNOW ABOUT MONET

## 01 GODLESS

Although baptized a Catholic, Monet denounced the church in later life and became an atheist.

## 02 DEATHMASK

Monet painted his wife Camille on her deathbed:

"COLOUR IS MY DAY-LONG OBSESSION, JOY AND TORMENT. TO SUCH AN EXTENT, INDEED, THAT ONE DAY, FINDING MYSELF AT THE DEATHBED OF A WOMAN WHO HAD BEEN AND STILL WAS VERY DEAR TO ME, I CAUGHT MYSELF IN THE ACT OF FOCUSING ON HER TEMPLES AND AUTOMATICALLY ANALYSING THE SUCCESSION OF APPROPRIATELY GRADED COLOURS WHICH DEATH WAS IMPOSING ON HER MOTIONLESS FACE."

—Monet to Georges Clemenceau, 1926

## 03 STAY-ABED

On days when the weather was too bad for him to paint outdoors, Monet would become inconsolable and refuse even to get out of bed.

## 04 DÉJEUNER

Lunch in Monet's Giverny household was served promptly at 11.30am, to enable the artist to capitalize on the afternoon light. Guests were never invited for dinner because Monet retired to bed at 9pm and rose at dawn to paint.

## 05 DIVERSION

When Monet tapped the Epte River to feed his water garden he fell foul of the law, but his friend Georges Clemenceau (below), a prominent journalist, politician and future French prime minister, stepped in to help the artist receive official permission to divert the river.

# 03
# WORK

# "I'M CHASING THE MEREST SLIVER OF COLOUR. IT'S MY OWN FAULT. I WANT TO GRASP THE INTANGIBLE."

—Claude Monet

# INFLUENCES

Three areas of influence – *plein air* painting, *Japonisme* and the artist's home and garden at Giverny – combined to dictate Monet's output.

His desire to document his surroundings and imbue his work with a sense of ever-changing climatic and atmospheric conditions was an ambition he could physically never fully realize – compounded when his sight began to fail – and so he contrived his environment in the form of his cherished garden, where he could still paint outdoors yet retreat with his canvases into his airy studio to work and rework his paintings.

The Oriental aesthetic was evident not only in his garden design, with its languid lily pond and hump-backed bridge, but also in his paintings – the 'Ukiyo-e' principles of elongated formats (*Cobeas*, 1883), tight cropping of an image around its subject (*The Manneporte*, 1883), asymmetrical composition (*The Studio Boat*, 1876), and even aerial perspective (*Boulevard des Capucines*, 1873–1874) all figure in Monet's work.

**GIVERNY**

**Water
Light
Shadow
Reflection
Movement**

**Series paintings
Landscapes
Views from studio boat
Seascapes
Architectural studies
Atmospheric effects
Rapid brushstrokes
Broken colour**

**PLEIN AIR
PAINTING**

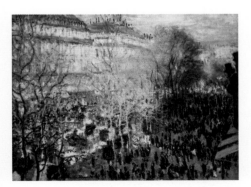

◀ *Carnival, Boulevard des Capucines*
Oil on canvas, 1873
24 x 32 inches
(61 cm x 80 cm)

MONET

54

Horticulture
Planting plans
Landscaping

Water gardens
Japanese bridge
Water lilies
Exotic cultivars
Oriental decor

JAPONISME

CLAUDE MONET

Ukiyo-e prints

Composition
Cropping
Themes from daily life
Colour

# ANATOMY OF A PAINTING #1

Argenteuil, which lies on a picturesque stretch of the Seine, 6.8 miles (11 km) northwest of Paris, became a centre of artistic activity for the Impressionists in the early 1870s. Monet and Camille settled there in 1872 on their return from London, and Monet would often be joined by his friends Renoir, Manet and Sisley, to paint along the banks of the river. Rarely has a single location been so exhaustively represented as in the river views, bridges, streets and gardens in the paintings.

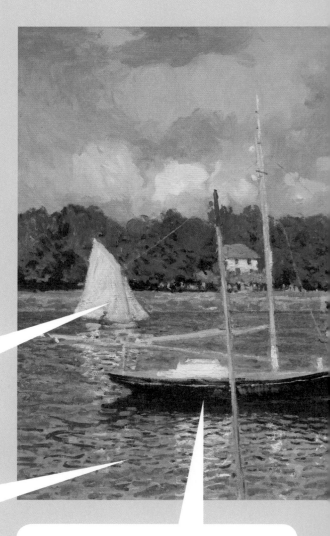

## SAILBOAT

Deft strokes of white and tones of blue capture the gliding sailboat and its mariner.

## MOVEMENT

Monet's painting, viewed from a few yards away, radiates sunlight, reflections and the movement of the rippling water passing under the bridge.

## BOAT

The dark-hulled boat, just off-centre, and the mast of an unseen boat, anchors the scene to the elevated riverbank, where the artist stands behind his easel.

## BACKGROUND

Daubs of colour coalesce into the sunlit bodies of figures on the far bank, while there is a sense of depth stretching beneath the shadows of the tree canopy, with sunlight beyond.

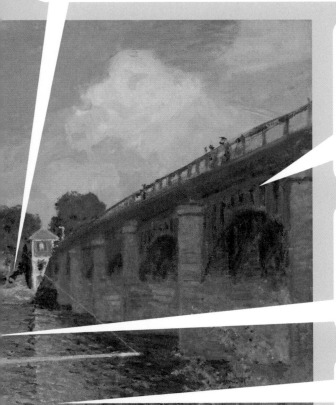

## BRIDGE

The solidity of the bridge, which draws the eye into the centre of the painting, is under-lit with colour to suggest the flickering reflections of the water.

## ROWING BOAT

Streaks of colour meld to form the little rowing boat and its occupants, one shaded by a parasol.

## BRUSHSTROKES

Looking closer, the scene has been captured with brushstrokes of unblended blue, green, yellow and red – light and fleeting strokes to denote lapping water and glistening reflections, larger and thicker strokes to suggest the bulk of the windblown trees in the background.

*The Bridge at Argenteuil* ▲
Oil on canvas, 1874
23 x 31 inches (60 x 79 cm)

# MONET'S PALETTE

Early in his career, Monet used dark colours, as in *A Corner of the Studio* (1861), which contains shades of black and resembles the style of his friend Gustave Courbet and the Realist school, but he later abandoned dark tones and worked from a limited palette of pure light colours. Black was rarely used, and greys and dark tones – including shadows – were created with complementary colours, blue depicting the reflection of the sky onto surfaces. In *Argenteuil* (1875), the shadows are purple.

"AS FOR THE COLOURS I USE, WHAT'S SO INTERESTING ABOUT THAT? I DON'T THINK ONE COULD PAINT BETTER OR MORE BRIGHTLY WITH ANOTHER PALETTE. THE POINT IS TO KNOW HOW TO USE THE COLOURS, THE CHOICE OF WHICH IS, WHEN ALL'S SAID AND DONE, A MATTER OF HABIT. ANYWAY, I USE FLAKE WHITE, CADMIUM YELLOW, VERMILION, DEEP MADDER, COBALT BLUE, EMERALD GREEN, AND THAT'S ALL."

—Claude Monet, 1905

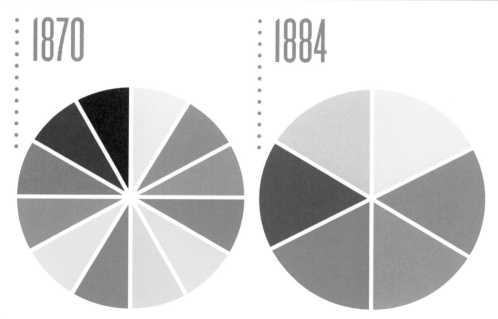

1870

1884

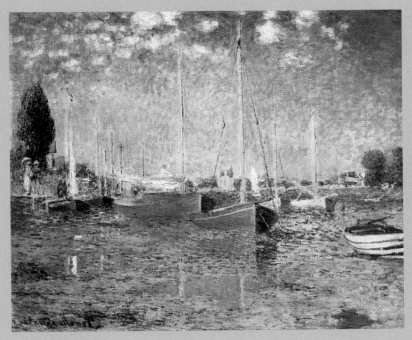

▲ *Argenteuil*
Oil on canvas, 1875
22 x 26 inches (56 x 67 cm)

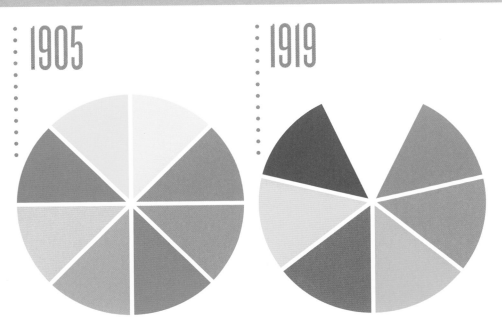

1905

1919

# ANATOMY OF A PAINTING #2

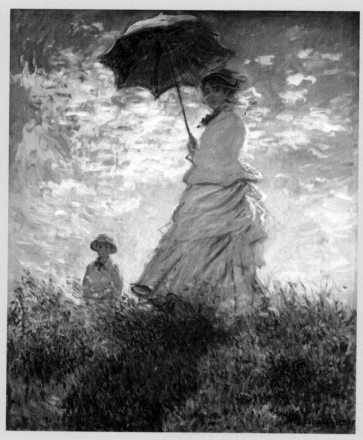

◀ ***The Promenade,***
***or Woman with***
***a Parasol – Madame***
***Monet and Her Son***
Oil on canvas, 1875
39 x 32 inches
(100 x 81 cm)

Painted during one of Monet's
most fertile periods, this early
impressionist work depicts his
wife Camille and their son Jean
on a family promenade near their
home in Argenteuil, on a breezy
summer's day.

## SNAPSHOTS

A precursor to his later series
paintings, Monet also produced
several other canvases depicting
what appear to be scenes from
the same stroll, as a modern-day
photographer would capture
family snapshots.

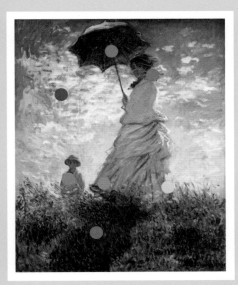

# REFLECTED GLOW

The yellow of the wild flowers is reflected against her dress.

# PARASOL

The green of the grass tints the underside of the parasol.

# SHADOW

Camille's shadow is thrown forward in the darker tones of the grass and flowers, giving a strong sense of three-dimensionality.

# SWIRLING SKIRT

The swirl of her skirt, the wisps of her veil and the writhing flowers at her feet impart a strong impression of the wind's strength.

# JEAN

Rosy-cheeked seven-year-old Jean, also exquisitely lit and shaded in the colours that surround him, stands farther away, behind the rising ground, increasing the sense of depth in the picture.

**The spontaneity and brevity of the scene was probably captured in a single session of just a few hours.**

# CLOUDS

Monet's brushwork is light and animated, using splashes of vibrant colour.

# CAMILLE

Camille's pose epitomizes the Impressionist concept of 'the glance', a moment frozen in time.

# LIGHT

Camille is viewed from a lower perspective against an azure sky streaked with white clouds. She is sunlit from behind, whitening her back and the top of her parasol.

# ON REFLECTION

**Ten years later, Monet revisited the subject with two similarly posed scenes of Suzanne, his second wife Alice's daughter, strolling with a parasol in a meadow at Giverny – one facing left, the other facing right.**

# REPEAT PERFORMANCE

Monet began his working life in the countryside and on the Normandy coast. After honing his skills in Argenteuil (aboard a floating studio on the Seine), London and Holland, he discovered Giverny and the house that would be his workplace for the rest of his life. There, Monet embarked upon series paintings and monumental canvases that explored the perception of nature and the passage of time.

- Haystacks series (25)
- Creuse Valley series (10)
- Poplar series (24)
- Rouen Cathedral series (30+)
- Morning on the Seine series (19)
- Charing Cross Bridge series (37)
- Houses of Parliament series (19)
- Works on 12 water lily paintings to be gifted to the State

63 YEARS

LIVES IN ARGENTEUIL

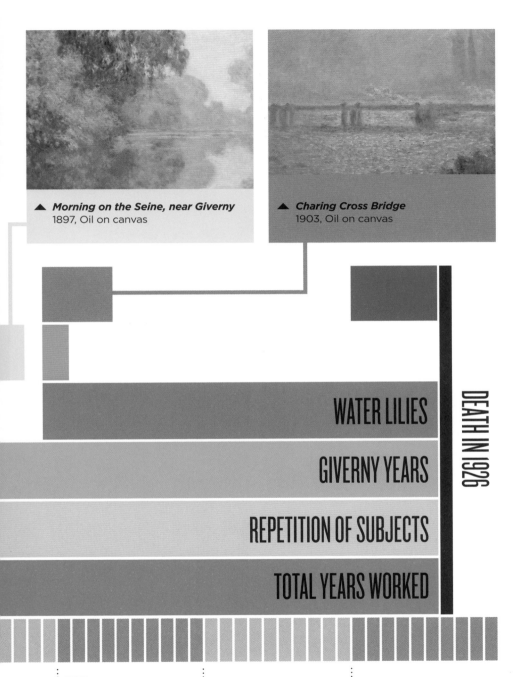

▲ **Morning on the Seine, near Giverny**
1897, Oil on canvas

▲ **Charing Cross Bridge**
1903, Oil on canvas

WATER LILIES

GIVERNY YEARS

REPETITION OF SUBJECTS

TOTAL YEARS WORKED

DEATH IN 1926

1900

1910

1920

# IN SERIES

In the latter years of the 1880s, Monet reflected on how his habit of returning to a location and painting the same view in different conditions of light, weather and atmosphere could be crafted as an intentional series.

While he had, over more than a decade, painted numerous motifs such as haystacks in the Giverny fields, his first true series was conceived in the Creuse Valley in central France, during the winter of 1889. Taking several canvases with him each day, he would start a new one when he noticed the light changing. The result: paintings of identical composition that displayed variations in tone, colour and texture – the passage of time rendered in oils.

OVER
**35** YEARS

MORE THAN
**400**
PAINTINGS

**8** MAJOR SERIES

## VALLEY OF THE CREUSE
1889
**10**

## HAYSTACKS
1890–1891
**25**

## POPLARS
1891
**24**

## ROUEN CATHEDRAL
1892–1893/94
**30+**

## MORNING ON THE SEINE
### 1896–1897
**19**

## THE HOUSES OF PARLIAMENT
### 1899–1901
**19**

## CHARING CROSS BRIDGE
### 1899–1904
**37**

## WATER LILIES
### 1899–1926
**250**

# MONET'S METHOD

Monet worked almost exclusively in oil on canvas. His loose, rapid style had less basis in line and form than classical painting, and used a bright palette of unmixed colours.

## IMPASTO

**Paint was applied impasto, laid thickly on the canvas by brush or palette knife.**

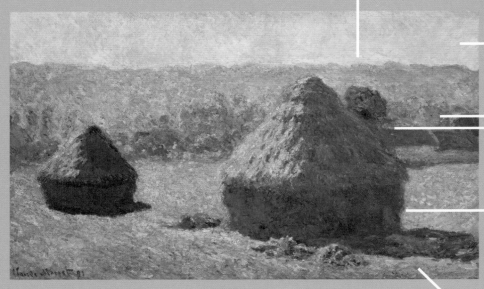

▲ *Grainstacks at the End of Summer, Morning Effect*
Oil on canvas, 1891
24 x 39 inches (60 x 100 cm)

## COMPOSITION

**Whereas classical paintings were composed to a rigid geometric formula, with the main subject commanding the viewer's attention, Impressionist composition used unusual focal points to frame a momentary action as if by a camera, with the sense of a broader reality beyond.**

## LIGHT GROUND

Traditionally, paint was applied to a red-brown or grey ground, but Monet painted directly onto a white, very pale grey or very light yellow ground.

## BRISTLES

The invention of the metal 'ferrule' allowed production of flat brushes (as opposed to traditional round) and 'tache' (blot) brushwork, which was the basis of Impressionist technique.

## BROKEN COLOUR

Monet blended paint optically on the canvas rather than on the palette. A brown may contain strokes of red, blue and yellow, but would appear brown from a distance.

## SCUMBLING

Monet 'scumbled' colours, adding a layer of broken, speckled or scratchy colour over another colour, which showed through to give a sense of depth and variation.

## BLENDING

Colours were laid side by side with little or no mixing, or wet paint was applied to wet paint, softening the edges.

# ANATOMY OF A PAINTING #3

In 1893, Monet bought land adjoining his property at Giverny and embarked upon a grand landscaping project that resulted in a spectacular water lily pond traversed by an elegant Japanese-style humpbacked footbridge. He was, in effect, manipulating nature to provide him with a source of motifs for his painting.

In the summer of 1899, he began a series of 18 views of the wooden structure, 12 of which he completed to his satisfaction. *The Japanese Bridge* differs from other paintings in the series due to its vertical format, influenced by Ukiyo-e, which focuses attention on the reflections in the pond.

## BACKGROUND

A background of weeping willows, maples, bamboos and Japanese peonies throws the image of the bridge forward, while its darker central section suggests depth beyond the picture.

## BRIDGE

The structure of the bridge, although solid in appearance, is created by hesitant streaks of pale and dark green illuminated with white and under-coloured with red to suggest the reflection of the water.

## LILY FLOWERS

The lily flowers are textured splodges of white.

## LILY PADS

Impasto daubs of yellows, pinks and reds, applied horizontally, with streaks of dark shadow beneath, coalesce into the delicate forms of lily pads, seemingly floating on the surface of the pond and giving the impression of depth to the water.

## WATER

When examined in close detail, the mirror-like surface of the water is created predominantly by vertical streaks of pure colour, reflections of the foliage surrounding the pond with glimmers of blue sky.

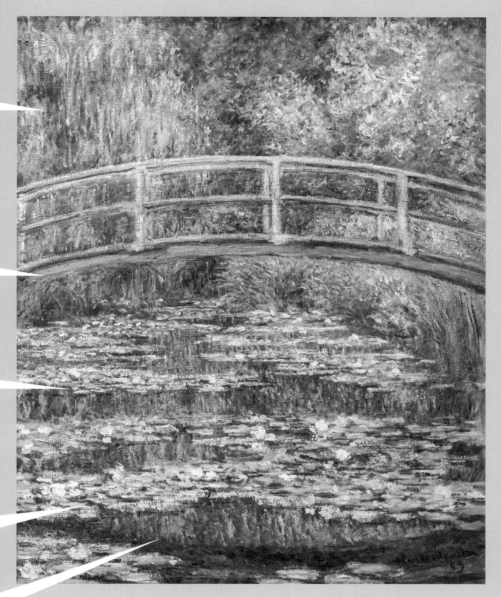

*The Japanese Bridge* ▲
Oil on canvas, 1899
36 x 29 inches (92 x 73 cm)

# POND LIFE

## OVER A PERIOD OF ALMOST 30 YEARS MONET PAINTED
# 250 OIL PAINTINGS OF WATER LILIES

> " ...THE ILLUSION OF AN ENDLESS WHOLE, OF WATER WITHOUT HORIZON OR BANK."
>
> —Claude Monet

= 1 painting

Although the water lilies in Monet's Giverny garden had been a subject as early as 1895, his *Water Lilies* series was not begun until 1902. The paintings ranged from modest-sized canvases to vast murals that explore the shimmering surface of the water with the surrounding trees and lush bank revealed only through reflections, with fronds of water plants beneath the surface and clouds reflected above.

In 1915 Monet devised his 'Grande Décoration', a series of monumental water lily paintings to be displayed in an oval room to create a panorama that would envelope the viewer. The installation is now located in two oval rooms in the Musée de l'Orangerie in Paris.

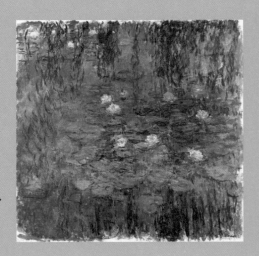

**Blue Water Lilies** ▶
Oil on canvas, 1916–19
79 x 79 inches
(200 x 200 cm)

# BIG IDEAS

MANY OF MONET'S CANVASES WERE TRULY AMBITIOUS IN SCALE, WHICH CALLED FOR HIM TO CONSTRUCT A TAILOR-MADE STUDIO WITH HUGE ROOF LIGHTS TO PROVIDE ADEQUATE ILLUMINATION

**Lunch on the Grass (left panel)**
(1865–66)
165 x 59 inches
(418 x 150 cm)

**The Path through the Irises**
(1914–17)
79 x 71 inches
(200 x 180 cm)

**The Water Lilies: Morning with Willows**
(1915–1926)
79 x 502 inches
(200 x 1275 cm)

## BIG WAVE

Even Monet's most massive paintings would have been dwarfed by the largest painting ever created by a single artist: *The Wave*, painted in 2007 by Croatian artist Đuka Siroglavic. Measuring 20,000 ft (6,100 m) wide by 59–67 inches (1.5–1.7 m) high, covering an area of 10,800 m², it weighs more than 11,000 lb (5,000 kg) and contains more than 5,510 lbs (2,500 kg) of paint.

# CLAUDE MONET

# 04
## LEGACY

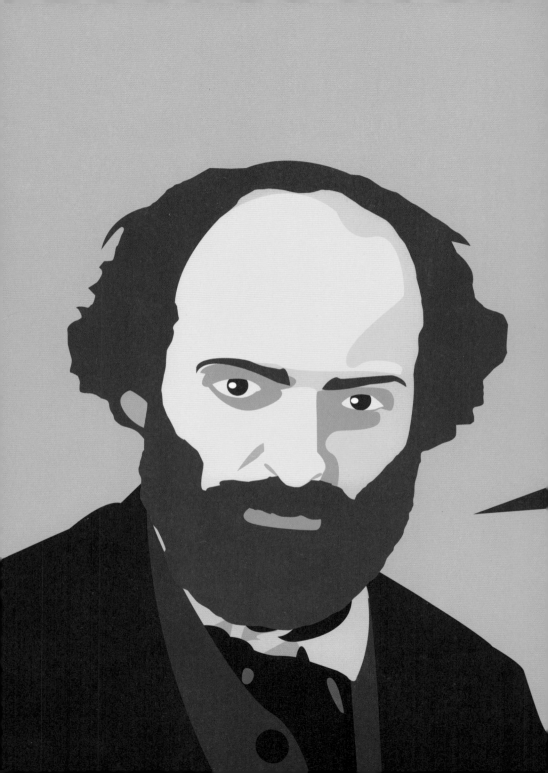

# "HE'LL BE IN THE LOUVRE, FOR SURE, ALONGSIDE CONSTABLE AND TURNER. DAMN IT, HE'S EVEN GREATER. HE PAINTED THE IRIDESCENCE OF THE EARTH."

—Paul Cézanne

# KEY WORKS

| 1873 | Camille and Jean Monet in the Garden at Argenteuil | **Romanticism** (1790–1850) |
| | Camille Monet on a Garden Bench | |
| | The Artist's House at Argenteuil | **Realism** (1830s–1880s) |
| | The Luncheon | |
| | Wild Poppies, near Argenteuil | **Impressionism** (1872–1892) |
| 1874 | Boulevard des Capucines | |
| | The Studio Boat | **Post-Impressionism** (early 1880s–1914) |
| 1875 | The Promenade, or Woman with a Parasol | |
| 1876 | Camille Monet in Japanese Costume | **Symbolism** (1880–1910) |
| | The Gare Saint-Lazare: Arrival of a Train | |
| 1877 | Saint-Lazare Station | **Modern Art** (1860–1960) |
| 1880 | Blanche Hoschedé | |
| 1885 | The Rock Needle and the Porte d'Aval | **Art Nouveau** (1890–1905) |
| 1886 | Woman with a Parasol or Study of a Figure Outdoors, Facing Left | |
| 1891 | Grainstacks at the End of Summer, Morning Effect | **Fauvism** (1905–1910) |
| | Poplars on the Banks of the Epte, Autumn | **Expressionism** (1905–1933) |
| 1893 | Rouen Cathedral | |
| 1898 | Charing Cross Bridge | **Cubism** (1907–1922) |
| 1899 | The Japanese Footbridge and the Water Lily Pool, Giverny | |
| 1901 | Leicester Square at Night | **Futurism** (1909–late 1920s) |
| 1904 | Houses of Parliament, Fog Effect | |
| 1907 | Water Lilies | **Dada** (1916–1924) |
| 1908 | Palazzo Dario | |
| | The Grand Canal and Santa Maria della Salute | **Bauhaus** (1919–1933) |
| 1913 | The Artist's House at Giverny | |
| 1916 | Blue Water Lilies | |
| 1917 | Yellow Irises with Pink Cloud | |
| 1920-26 | Water Lilies Pond | |
| 1922 | Path under the Rose Trellises, Giverny | |
| 1926 | The Japanese Bridge at Giverny | |
| | Water Lily Pond, Evening (left panel) | |

START HERE

**NEOCLASSICISM**
*c.* 1770–1860
Jacques-Louis David
JAD Ingres
Sir Joshua Reynolds
Elisabeth Vigée-Lebrun

**ROMANTICISM**
*c.* 1790–1850
Francisco de Goya
William Blake
Eugène Delacroix
Caspar David Friedrich

Seen in historical context, Monet and the groundbreaking Impressionists lie at the epicentre of a period of dramatic change in art. This began with the 18th-century Romanticists' reworking of the austere Neoclassical depiction of classical events, characters and themes, and giving some prominence to the heroic element.

The Realists, and their recording of everyday life, sprang from the rapid changes in industrial and social conditions of the 19th century and the decline of romantic individualism.

This in turn led to the Impressionists' attempts to capture the fleeting passage of light in a looser, less formal style. Their use of bright, non-naturalistic colours ultimately made way for the more abstract approach to art that, in the 20th century, diverged from nature as its main subject matter, with the expression of non-physical emotions, and the surreal.

**SYMBOLISM**
*c.* 1880–1910
Gustave Moreau
Arnold Böcklin
Ferdinand Hodler
Max Klinger

**FAUVISM**
*c.* 1905–1910
Henri Matisse
Albert Marquet
Maurice de Vlaminck
André Derain

**CUBISM**
*c.* 1907–1922
Pablo Picasso
Georges Braque
Juan Gris
Ferdinand Léger

**EXPRESSIONISM**
*c.* 1905–1933
Vincent van Gogh
Paul Gaugin
Edvard Munch
Egon Schiele

**DADA**
*c.* 1916–1924
Jean Arp
Marcel Duchamp
Max Ernst
Francis Picabia

**SURREALISM**
*c.* 1924–2004
Man Ray
René Magritte
Salvador Dalí
Yves Tanguy

# MONET'S PLACE IN ART

## HUDSON RIVER SCHOOL (USA)
*c.* 1825–1875
Thomas Cole
Albert Bierstadt
Frederic Edwin Church
Asher B Durand

## REALISM
*c.* 1830–1880s
Gustave Courbet
Jean-François Millet
Honoré Daumier
Ilya Repin

## PRE-RAPHAELITE BROTHERHOOD
1848–1855
William Holman Hunt
John Everett Millais
Dante Gabriel Rossetti
Ford Maddox Brown

## ENGLISH SCHOOL OF LANDSCAPE PAINTING
1700–1900
John Constable, JMW Turner, JR Cozens
Thomas Gainsborough

## BARBIZON SCHOOL (FR)
1830–1875
Jean-Baptiste-Camille Corot
Théodore Rousseau
Charles-François Daubigny
Jean-François Millet

## IMPRESSIONISM
1872–1892
Mary Cassatt
**Claude Monet**
Edgar Degas
Alfred Sisley
Camille Pissarro
Gustave Caillebotte
Pierre-Auguste Renoir
Berthe Morisot

## MODERN ART
*c.* 1860–1960

## CAMDEN TOWN GROUP (UK)
1905–1920
Walter Sickert
Spencer Gore
Walter Bayes
Robert Bevan

## AMERICAN IMPRESSIONISM
*c.* 1880–1900
George Inness
James McNeill Whistler
Henry Ward Ranger
Mary Cassatt

## POST-IMPRESSIONISM
*c.* 1880–1914
Paul Cézanne
Henri de Toulouse-Lautrec
Maurice Utrillo
Georges Seurat

## UKIYO-E
*c.* 1603–1867
Katsushika Hokusai
Utagawa Hiroshige
Utagawa Toyoharu

## FUTURISM (IT)
1909–1920s
Carlo Carrà
Giacomo Balla
Gino Severini
Umberto Boccioni

## NEO-IMPRESSIONISM
1880s
Georges Seurat
Paul Signac
Camille Pissarro
Albert Dubois-Pillet

## ART NOUVEAU
*c.* 1890–1905
Jules Chéret
Alphonse Mucha
Gustav Klimt
Aubrey Beardsley

## VORTICISM (UK)
*c.* 1914–1915
Percy Wyndham Lewis
David Bomberg
Jacob Epstein
Edward Wadsworth

## POINTILISM/DIVISIONISM
1884–1900
Georges Seurat
Paul Signac
Henri-Edmond Cross
Maximilien Luce

## BAUHAUS DESIGN SCHOOL
1919–1933
Walter Gropius
Paul Klee
Wassily Kandinsky
Lyonel Feininger

# HIS OWN WORST CRITIC

**15** of the defaced paintings were worth...
## $100,000
in 1908

that's
## $2,631,578.95
today!

Despite the serenity of his Giverny scenes, during 1908 and 1909 Monet defaced or destroyed more than 30 of his *Water Lily* paintings – the fruit of eight years' labour – laying into them with a knife because he felt they were not good enough for the public and critics to see.

**More than**
## 30
*Water Lily* **paintings destroyed**

# OTHER ARTISTS WHO DESTROYED THEIR OWN WORK...

## FRANCIS BACON (1909 – 1992)

The Irish-born British figurative painter destroyed much of his early work. After his death his studio was found to contain 100 slashed canvases.

## PABLO PICASSO (1881 – 1973)

When struggling to make his way in art, the Spanish painter would obliterate pictures he was unhappy with because he could not afford to buy a fresh canvas.

# MANY MONETS?
## CLAUDE MONET

## VINCENT VAN GOGH

## PERHAPS THE MOST PROLIFIC OF ALL...
# PABLO PICASSO

# 2,500 : 40 : 62.5
## PAINTINGS : YEARS : PER YEAR

 = 100 PAINTINGS

**Despite his prodigious output, how prolific was Monet compared to other famous artists?**

# 2,100 : 10 : 210
## PAINTINGS : YEARS : PER YEAR

 = 100 PAINTINGS

# 13,500 : 75 : 180
## PAINTINGS : YEARS : PER YEAR

PLUS... 10,000 prints and engravings 34,000 book illustrations and 300 sculptures and ceramics

 = 250 PAINTINGS

**National Gallery of Art, Washington D.C., USA**

INCLUDING:
- *Argenteuil* (c. 1872)
- *Ships Riding on the Seine at Rouen* (1872–1873)
- *Banks of the Seine, Vétheuil* (1880)
- *Rouen Cathedral West Façade* (1894)
- *Water Bridge, Gray Day* (1903)

**Museum of Fine Arts, Boston, USA**

# 36 WORKS

INCLUDING:
- *The Japanese (Camille Monet in Japanese Costume)* (1876)
- *Camille Monet and a Child in the Artist's Garden in Argenteuil* (1875)
- *Water Lilies* (1905)
- *Grainstack (Snow Effect)* (1891)
- *Rouen Cathedral* (various)

**The Metropolitan Museum of Art, New York, USA**

# 40 WORKS

INCLUDING:
- *Garden at Sainte-Adresse* (1867)
- *Bridge over a Pond of Water Lilies* (1899)
- *Houses on the Achterzaan* (1871)
- *Poppy Fields near Argenteuil* (1875)
- *Morning on the Seine near Giverny* (1897)
- *Rouen Cathedral: The Portal (Sunlight)* (1894)
- *Camille Monet on a Garden Bench* (1873)
- *Dr Leclenché* (1864)

**Scottish National Gallery, Edinburgh, Scotland**

- *Haystacks (Snow Effect)* (1891)

**National Gallery, London, England**

- *Bathers at La Grenouillère* (1869)

**Tate Britain, London, England**

- *Water Lilies* (1916–26)

**São Paulo Museum of Art, São Paulo, Brazil**

- *Japanese Bridge* (1920–1924)
- *Canoe on the Epte* (1890)

# WHERE'S MONET?

So prolific was Monet that paintings by the great Impressionist can be viewed in a large number of art galleries and museums throughout Europe and beyond. Here are just a few of the key works and the major galleries where they can be found on permanent display.

MONET

## Musée Marmottan Monet, Paris, France

# 94 PAINTINGS, 29 DRAWINGS 2 OF THE ARTIST'S PALETTES

- *Impression, Sunrise* (1872)
- *Water Lilies* (1915)

## Musée des Beaux Arts, Rouen, France

- *Rouen Cathedral: Façade and Tour d'Albane, Grey Weather* (1894)
- *Le Seine à Port-Villez* (1894)
- *Rue Saint-Denis, Fête of 30 June 1878* (c. 1878)

## Musée d'Orsay, Paris, France

# 88 WORKS

INCLUDING:
- *Lunch on the Grass* (1865/66)
- *Women in the Garden* (1866)
- *The Magpie* (1868/69)
- *Poppies* (1873)
- *Rouen Cathedral* (1893) (Plus a selection of early works)

## Musée de Vernon, Vernon, France
(3 miles/5 km from Giverny)

- *Water Lilies* (1908) (Circular work)
- *The Cliffs of Pourville at Sunset* (1896) (Also paintings by Blanche Hoschedé-Monet)

## Kröller-Müller Museum, Otterlo, The Netherlands

- *The Studio Boat* (1874)
- *Portrait of Mlle Guurtje van de Stadt* (1871)

## National Museum of Western Art, Tokyo, Japan

# 17 WORKS

INCLUDING:
- *Heavy Sea at Pourville* (1897)
- *Snow in Argenteuil* (1875)
- *Water Lilies* (1916)
- *Poplars in the Sun* (1891)
- *Charing Cross Bridge* (1902)
- *Yellow Irises* (c. 1914–17)
- *Vétheuil* (c. 1902)

## Musée de l'Orangerie, Paris, France

STAR WORKS:
- *Water Lilies* (1920–26) (8 panels in 2 consecutive oval rooms, lit with natural light from above)

## Kunsthalle, Bremen, Germany

- *Camille* (1866)

## National Gallery of Australia, Canberra, Australia

- *Haystacks, Midday* (1890)
- *Water Lilies* (c. 1914–1917)

# TYPOGRAPHIC MONET

Alice Hoschedé  Blanche  impasto

Giverny  colour

Impression: Sunrise

windmills

Rouen Cathedral  emerald green  Zaandam

Monet  Vernon  Bazille

Claude chain smoker  typhoid  La Grenouillère

six stepchildren

The Japanese Bridge

Argenteuil  Durand-Ruel  poplars  series

Nadar  cadmium yellow  London  flake white

light  canvas  broken colour

lung cancer  parasol

Caillebotte

Water Lilies

Camille Vétheuil

Creuse Valley Jean

Seine

Haystacks

penniless artist Venice

Sainte-Adresse

Eugène Boudin Paris

caricaturist Trouville

Michel

deep madder Renoir

Grande Décoration

cataracts

Le Havre

plein air

wild poppies

beard

failing vision

bateau-atelier cobalt blue Panama hat

bathers

Impressionism

art obsessive

Aunt Marie-Jeanne Normandy

stubborn cigarettes Toulmouche vermilion Poissy gardening

Étretat

# MONEY, MONEY, MONET

*Meule (Grainstack)* (1891) became the most expensive Monet painting when it was auctioned at Christie's in London in 2016. The respectable price tag, beating the next Monet painting on the list by a million dollars, was, nevertheless, insufficient to nudge the artist posthumously into the top 10 most expensive paintings of all time, a list which starts at $152m and reaches a staggering $300m.

Monet's top five paintings are dominated by three of his later water lily canvases, and an early painting of the railway bridge at Argenteuil.

## When Will You Marry?
**Paul Gauguin**
1892, sold 2015

## The Card Players
**Paul Cézanne**
1892/3, sold 2011

## No.6 (Violet, Green and Red)
**Mark Rothko**
1951, sold 2014

## Les Femmes d'Alger (Version O)
**Pablo Picasso**
1955, sold 2015

## Nu Couché
**Amedeo Modigliani**
1917/18, sold 2015

## 1948
**Jackson Pollock**
1948, sold 2006

## Woman III
**Willem de Kooning**
1953, sold 2006

## Le Rêve
**Pablo Picasso**
1932, sold 2013

## Portrait of Adele Bloch-Bauer I
**Gustav Klimt**
1907, sold 2006

## Portrait of Dr Gachet
**Vincent van Gogh**
1890, sold 1990

MONET

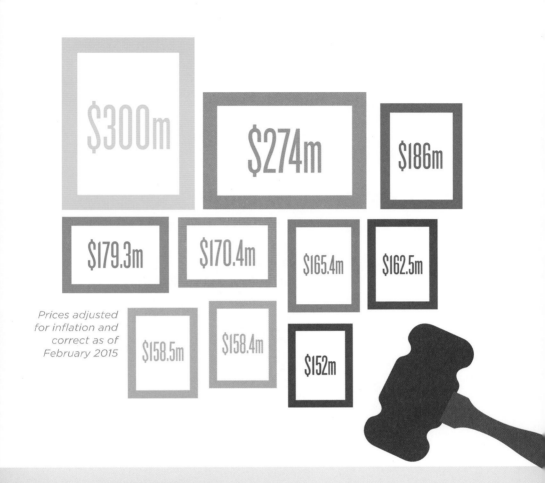

$300m

$274m

$186m

$179.3m $170.4m $165.4m $162.5m

Prices adjusted
for inflation and
correct as of
February 2015

$158.5m $158.4m

$152m

# MOST EXPENSIVE MONETS

**01** $81.4m *Meule (Grainstack)*
(1891)

**02** $80.4m *Water Lily Pond*
(1919)

**03** $53.9m *Water Lilies*
(1906)

**04** $43.8m *Water Lilies*
(1905)

**05** $41.4m *The Railway Bridge
at Argenteuil*
(1873)

# MONET'S HOUSE & GARDENS

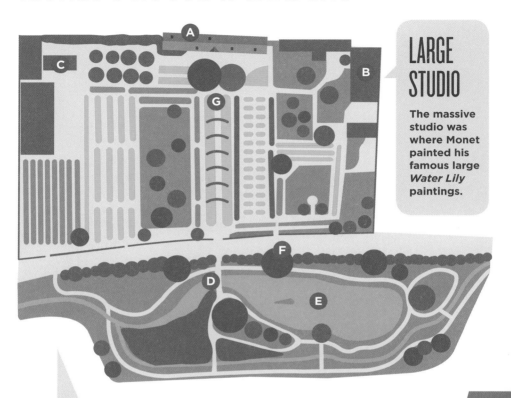

## KEY TO PLAN

- **A** THE HOUSE
- **B** LARGE STUDIO
- **C** SECOND STUDIO
- FLOWER BEDS
- **D** JAPANESE BRIDGE
- **E** WATER LILY POND
- **F** WEEPING WILLOW
- **G** CLOS NORMAND

F R A N C E

Monet was a passionate and knowledgeable gardener, obtaining seeds and plants from specialists and importing rare examples. He employed six gardeners – and the help of his family – but he weeded and watered the garden himself.

When Monet died in 1926, Michel, his surviving son, inherited the property at Giverny. As he was busy organizing African safaris, Blanche Hoschedé-Monet became custodian of the property, along with chief gardener, Louis Lebret. On Blanche's death in 1947, the garden was all but abandoned. When Michel died, heirless, in a car crash in 1966, the property and collections passed to the Académie des Beaux-Arts.

From 1977, Gérald Van der Kemp was pivotal in restoring the house and gardens, with the aid of American donors. On 1 June 1980, with the creation of the Fondation Claude Monet, the property opened its doors to the public.

## 500,000
### VISITORS A YEAR

# BIOGRAPHIES

## Georges Clémenceau (1841–1929)

French statesman who led the nation during the First World War and was Prime Minister from 1906–09 and 1917–20. A close friend of Monet, he was instrumental in persuading the artist to have a cataract operation in 1923.

## Gustave Geffroy (1855–1926)

One of the champions of the Impressionist movement, the Parisian journalist, art critic, historian and novelist befriended Monet in 1886 in Belle-Île-en-Mer, an island off Brittany, when the artist was painting coastal rock formations.

## Georges de Bellio (1828–1894)

A homeopathic physician of Romanian descent, de Bellio was one of the first collectors of Impressionism. Friend and doctor to Monet, Manet, Pissarro, Sisley and Renoir, he bought *Impression, Sunrise* at the exhibition of 1874.

## Paul Durand-Ruel (1831–1922)

The first French art dealer to support the Impressionists, he met Monet in London during their refuge from the Franco-Prussian War. His first major exhibition of Impressionist paintings was at New Bond Street, London.

## Eugène Boudin (1824–1898)

One of the first French landscape artists to paint outdoors, marine painter Boudin befriended 17-year-old Monet and persuaded him to abandon his caricature drawings in favour of landscapes. They remained lifelong friends.

## Pierre-Auguste Renoir (1841–1919)

Monet and Renoir met when studying art in 1862 and the friends became instrumental in the development of Impressionism, frequently painting the same views side-by-side, although Renoir became known for his exquisite figurative work.

## Jean Frédéric Bazille (1841–1870)

Born into a wealthy family, Bazille took up art after failing his medical exams. He became a close friend of Monet's when they studied in Charles Gleyre's studio, and generously supported his less well-off associate. He died at 28.

## Alice Hoschedé (1844–1911)

Wife of department store owner Ernest Hoschedé, Alice was the mother of his six children, although after the Hoschedé and Monet households combined in 1877, doubt was cast on whether Monet was father to Jean-Pierre, born that year. She married Monet in 1892.

## Gustave Caillebotte (1848–1894)

The son of an upper-class Parisian family, Caillebotte financed his own art career. His own style owed more to Realism, but he was a staunch patron of the Impressionists. He helped Monet with studio rental, and bought his first work in 1875.

## Blanche Hoschedé-Monet (1865–1947)

Married to Monet's son Jean, Blanche was his stepdaughter and daughter-in-law. She became Monet's assistant and student. After her mother and husband died she returned to Giverny to care for Monet for the rest of his life.

## Camille-Léonie Doncieux (1847–1879)

In her teens, she posed for Renoir, Manet and her future husband Claude Monet. She gave birth to Monet's son Jean in 1867, and to Michel in 1878. In poor health, she was nursed by Alice. She died in 1879, of unknown causes, possibly pelvic cancer or tuberculosis.

## Suzanne Hoschedé-Monet (1864–1899)

The eldest daughter of Alice and Ernest Hoschedé, Suzanne became the favourite model of her future stepfather, Claude Monet – the *Woman with a Parasol* in his 1886 painting. She married American Impressionist Theodore Earl Butler in 1892.

 family

 friend

# INDEX

# ACKNOWLEDGMENTS

## Picture credits

The publishers would like to thank the following for permission to reproduce their images in this book. Every effort has been made to acknowledge copyright holders, and the publishers apologize for any omissions.

**25 & 76** *Camille, or The Woman in a Green Dress,* 1866: Photo © Niday Picture Library / Alamy Stock Photo.
**25 & 76** *Breakwater at Trouville, Low Tide,* 1870: Photo © PRISMA ARCHIVO / Alamy Stock Photo.
**36** *The Studio Boat,* 1874: Photo © Niday Picture Library / Alamy Stock Photo.
**36** *Banks of the Seine, Vétheuil,* 1880: Photo © Everett – Art / Shutterstock.com.
**37** *The Seine at Giverny,* 1897: Photo © Everett – Art / Shutterstock.com.
**48 & 68–69** *The Japanese Bridge,* 1899: Photo © John Baran / Alamy Stock Photo.
**49** *Inside Kameido Tenjin Shrine (Kameido Tenjin Keidai), No. 65 from One Hundred Famous Views of Edo,* 1856: Photo © Brooklyn Museum.
**54** *Carnival, Boulevard des Capucines,* 1873: Photo © Everett – Art / Shutterstock.com.
**56–57** *The Bridge at Argenteuil,* 1874: Photo © Everett – Art / Shutterstock.com.
**59** *Argenteuil,* 1875: Photo © Everett – Art / Shutterstock.com.
**60–61** *The Promenade, or Woman with a Parasol,* 1875: Photo © Everett – Art / Shutterstock.com.
**63** *Charing Cross Bridge (overcast day),* 1896-1897: Photo © Artepics / Alamy Stock Photo.
**63** *Morning on the Seine, near Giverny,* 1900: Photo © Artepics / Alamy Stock Photo.
**66** *Grainstacks at the End of Summer, Morning Effect,* 1891: Photo © Everett – Art / Shutterstock.com.
**70** *Blue Water Lillies,* 1916-1919: Photo © Everett – Art / Shutterstock.com.
**76** *Impression: Sunrise,* 1872: Photo © Everett – Art / Shutterstock.com.

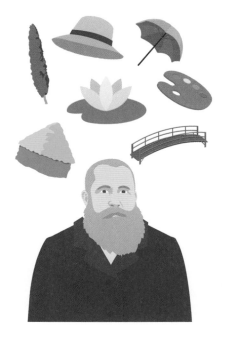

AMMONITE
**PRESS**

To place an order or request a catalogue, please contact:
**Ammonite Press**
GMC Publications Ltd, Castle Place, 166 High Street, Lewes, East Sussex, BN7 1XU, United Kingdom
Tel: +44 (0)1273 488006
www.ammonitepress.com